Hello, Little One

Hello, Little One

By Douglas Wood

Photography by Katharina Wood

NORTH STAR PRESS OF ST. CLOUD, INC.
St. Cloud, Minnesota

ISBN: 978-0-87839-812-6

First edition: September 2015

Printed in the United States of America.

Published by
North Star Press of St. Cloud, Inc.
P.O. Box 451
St. Cloud, MN

northstarpress.com

Dedications

To my grandchildren, and to all Little Ones everywhere,
who are born to dream and grow and become who they are.
~ Douglas

With love to the little ones who welcomed me
into motherhood, Maya and Henry.
~ Katharina

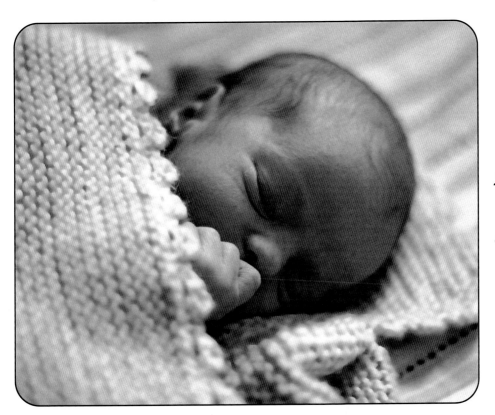

Hello, Little One.

Welcome.

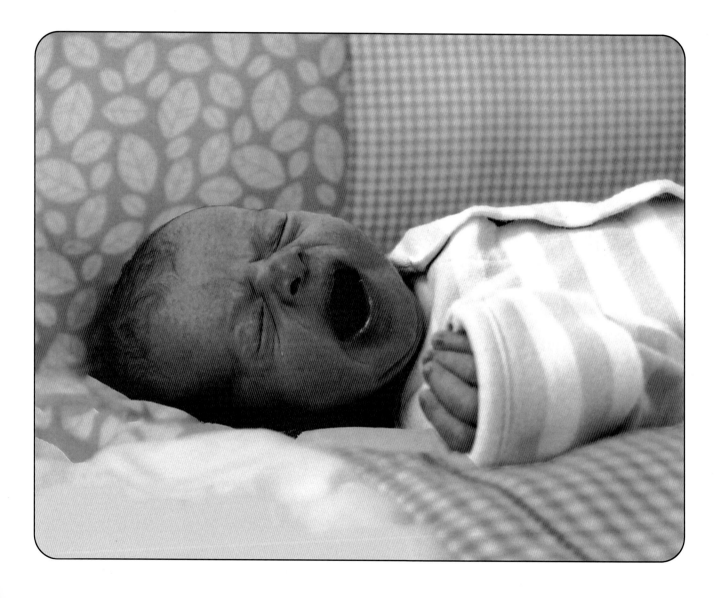

*This is your day,
the very beginning
of your life
in the world.*

And someone is holding you,
exactly as your mommy
and your daddy were held,
when they were tiny like you,
just a moment ago.

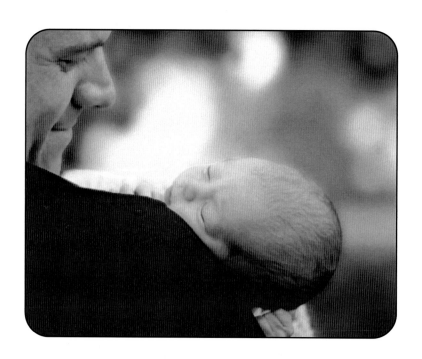

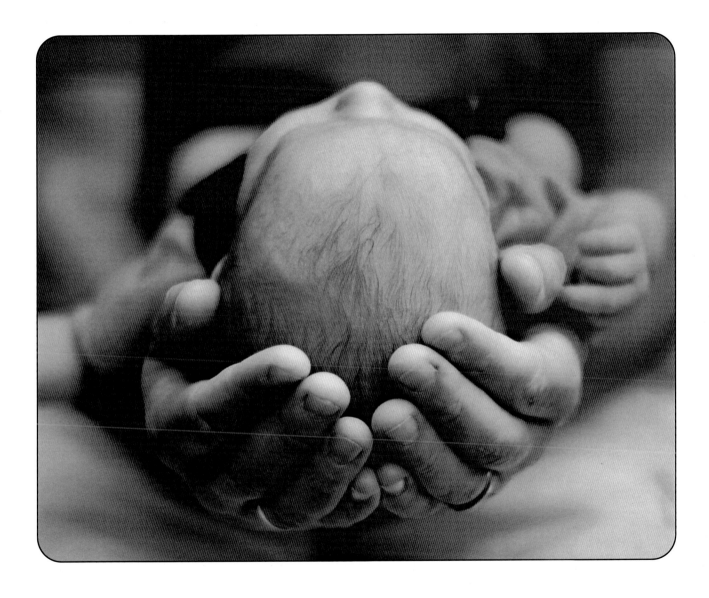

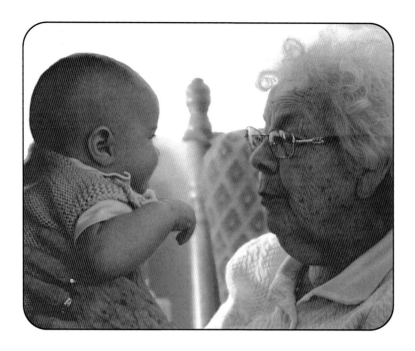

Now, some people may try to tell you
that it was a long time ago,
years ago.
But they are mistaken.

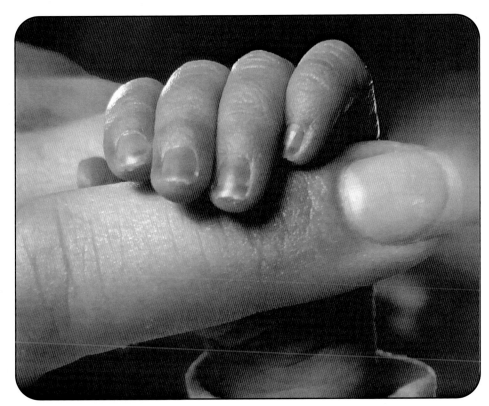

*It was just
a moment ago.*

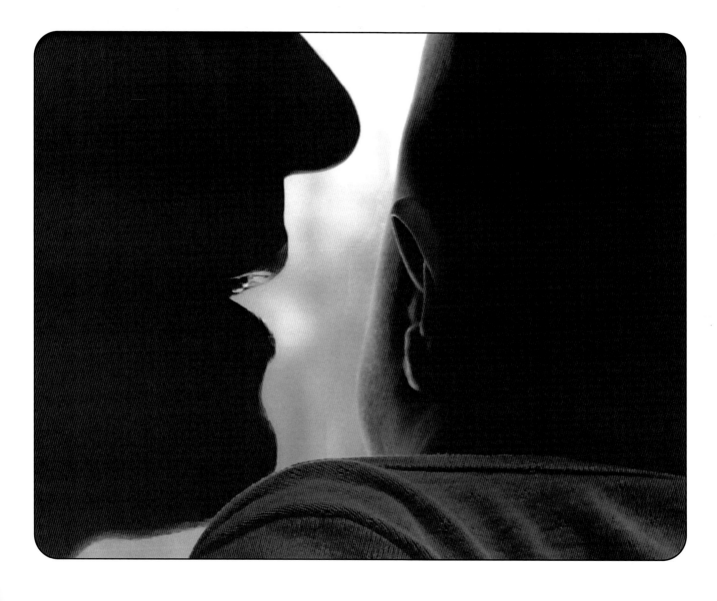

And here is a secret,
something that's been told
to all the Little Ones
who've ever been held,
two, and three, and four,
and a hundred moments ago . . .

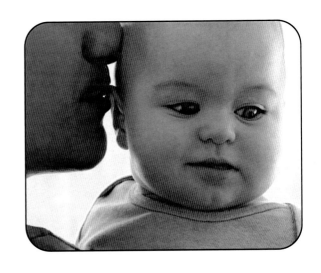

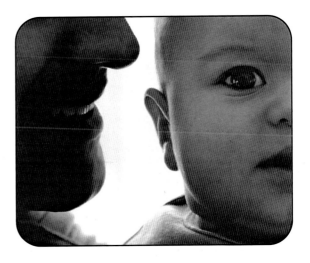

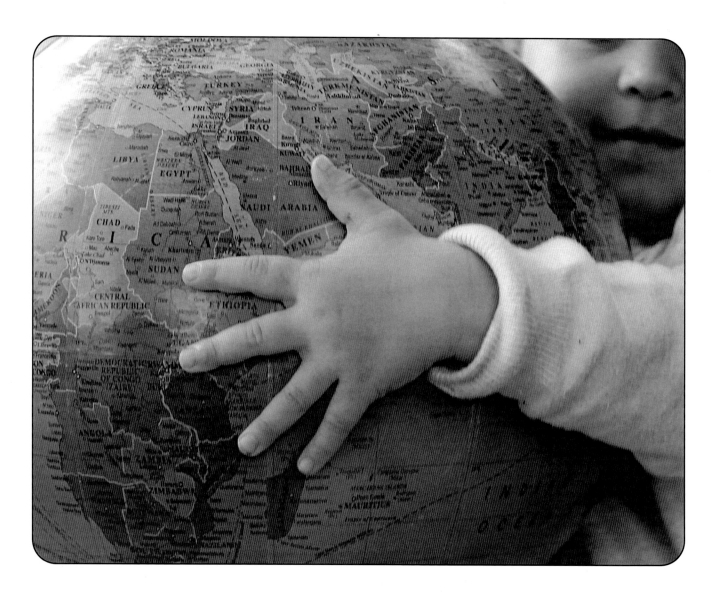

The world is new today,
and it was made just for you.

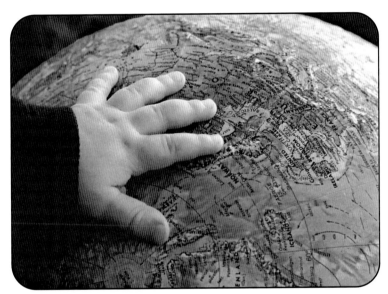

You may hear people say
that the world is old.
But again, they are mistaken.
For although the rocks are old
and the hills are old

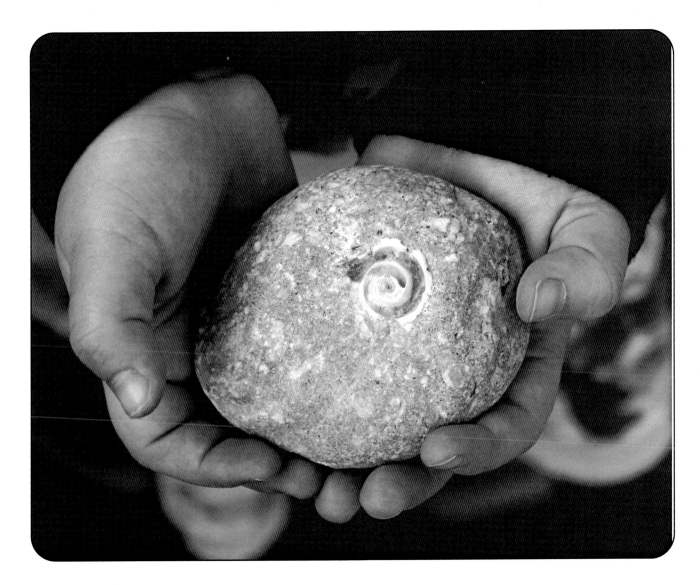

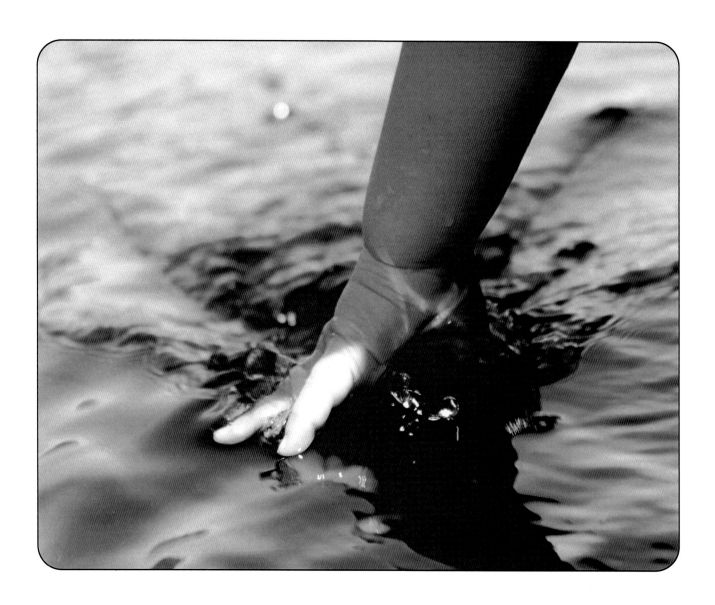

and the rivers are old
and the stars
and the mountains
and the valleys
and the oceans

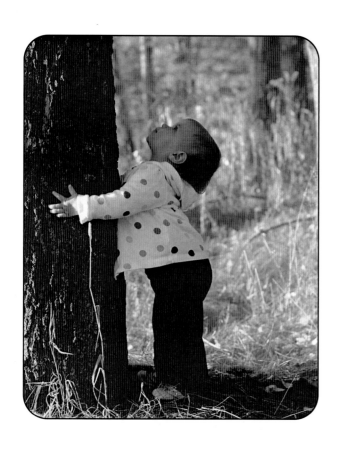

*and the trees
and even the people
are old . . .*

Still, today the world is new.
It's all scrubbed
and polished fine

for your eyes to see
and your ears to hear,
for your hands to touch
and your heart to love.

It is all new once more,
now you are here.

You might hear it said, Little One,
that all the best spots
are already taken,
the finest places
already bought
and sold and
rented out
and run down;

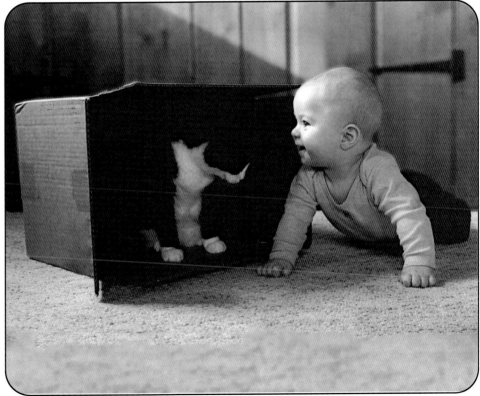

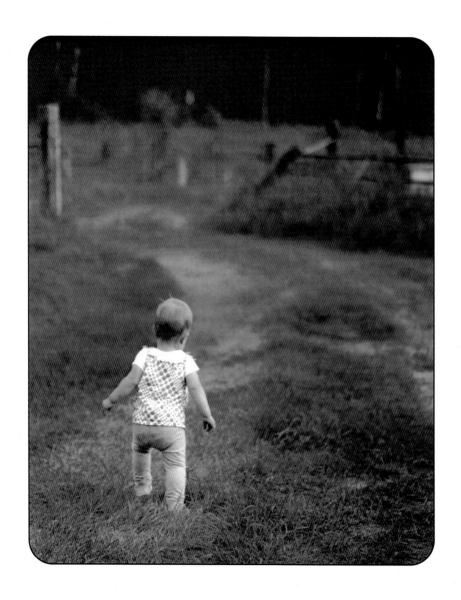

the wide horizons all explored
and parceled out,

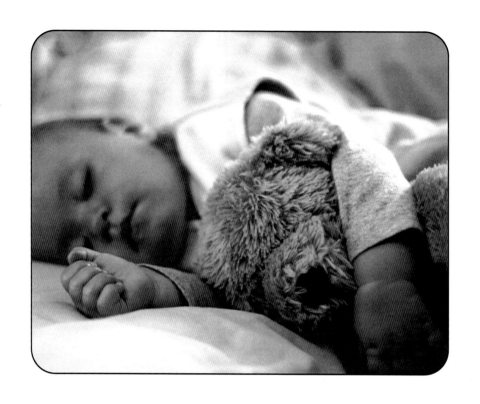

the most glorious dreams
already dreamed
and chased and won
and lost.

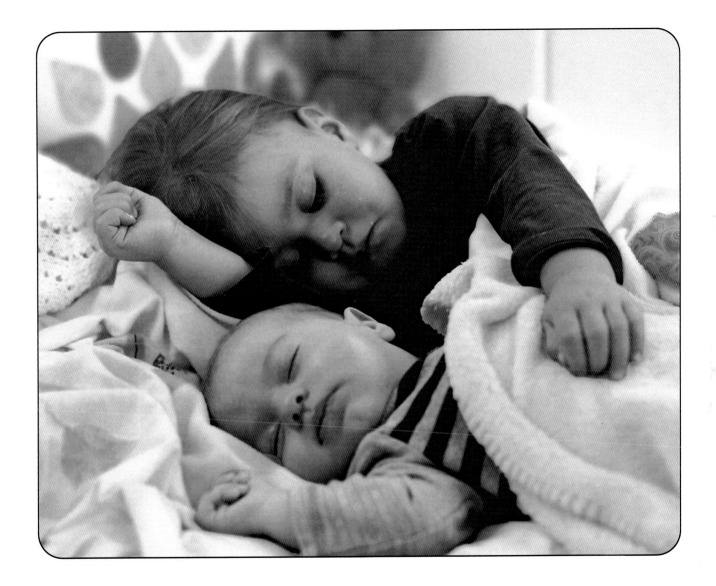

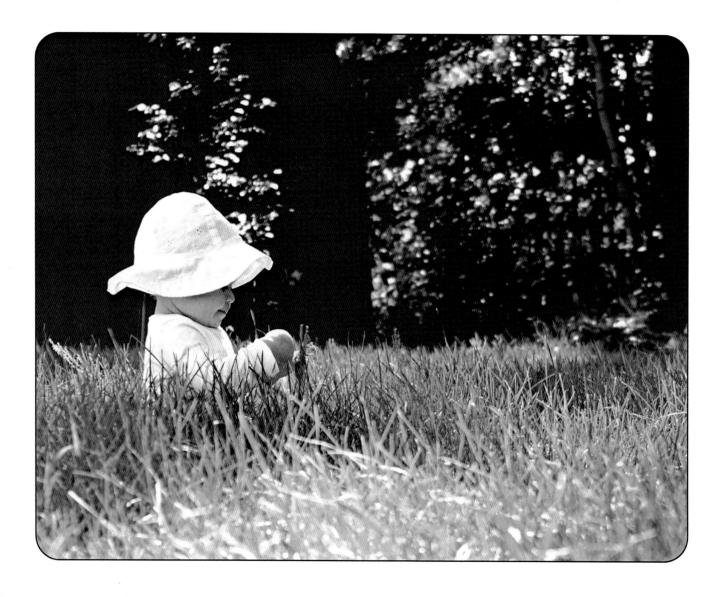

*But don't trouble your head
with such thoughts.*

*For those who think them forget
that each new age has its own
new and unknown horizons to explore,
beckoning and calling from beyond
what was called "unknown" before.*

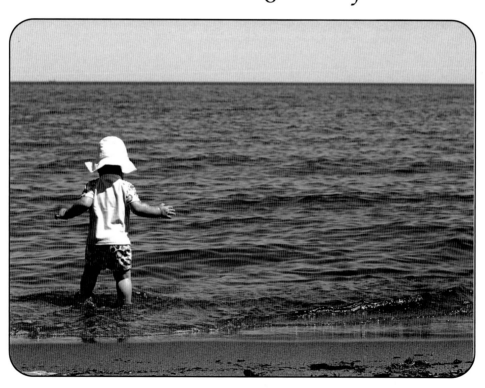

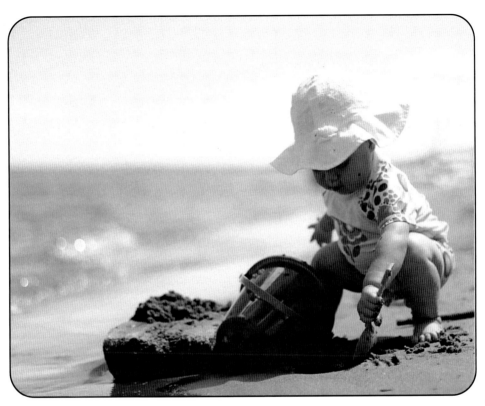

They have forgotten that every heart
is made to reach
for its own dreams,
to build its own castles,

on the ground or in the air;
and all the things that can be bought
and sold
are cheap,
compared to those that cannot.

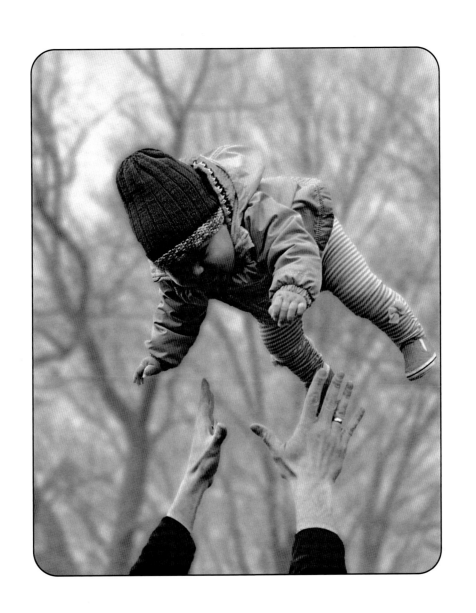

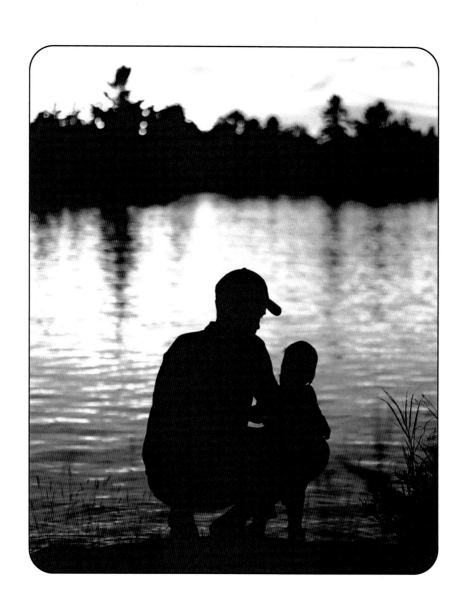

*For the gilded sunrises and sunsets
are yours, each one set ablaze
like a campfire for the soul.*

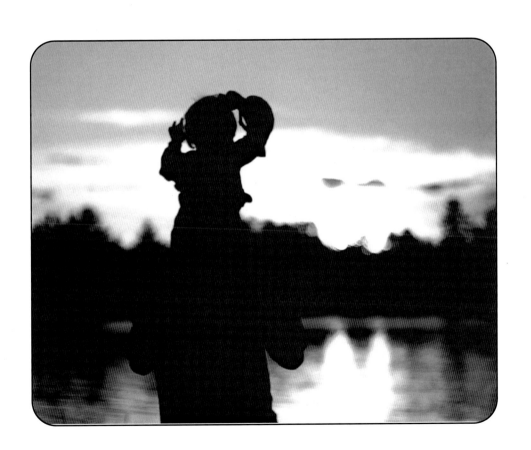

The silver hems of the clouds
and the diamonds of the night sky
belong to you, Little One,
as much as they belong
to anyone on Earth.

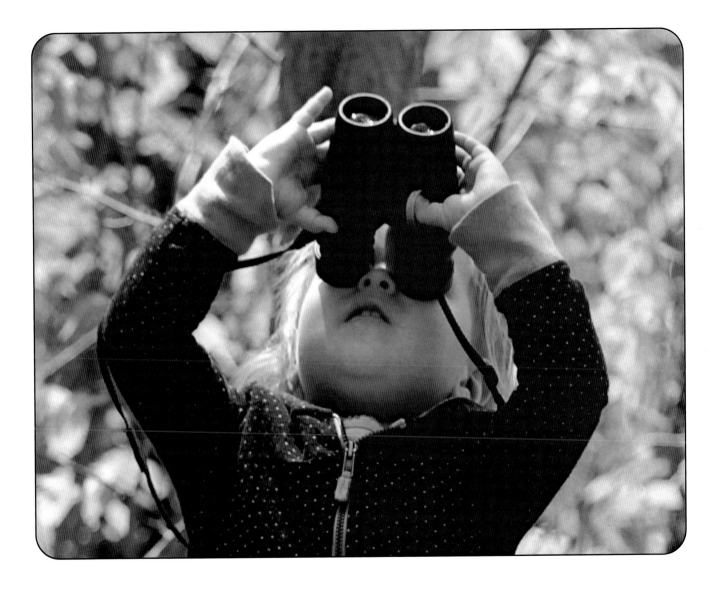

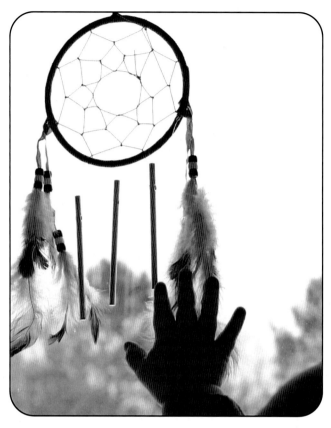

And the most valuable treasures of all,
those of the mind and heart—
knowledge
wisdom

self-respect
honesty
generosity
courage
love . . .

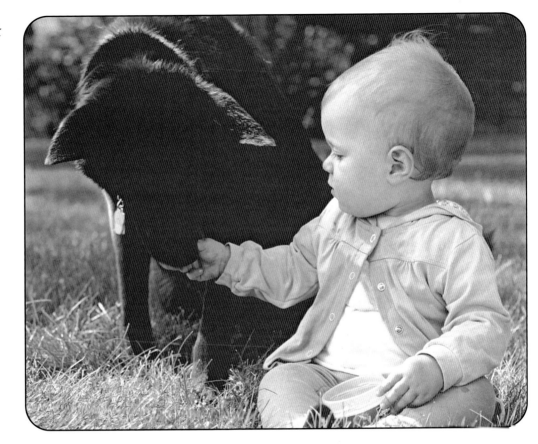

. . . No one can give these,
and no one can take them away.

They are gems entrusted
by the hand of Life
to you, Little One,
to your safe-keeping.

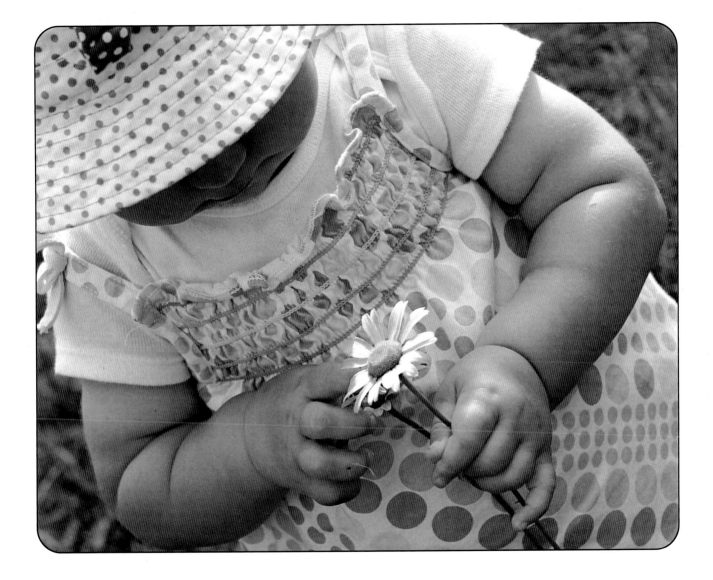

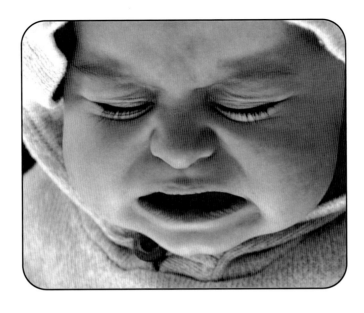

You will hear people say
that life is filled with care and trouble,
tinged with tragedy,
darkened by sorrow,
burdened by pain and loss.
Those who say such things
are not mistaken.

Life is hard.
It is a difficult journey
through rugged country.

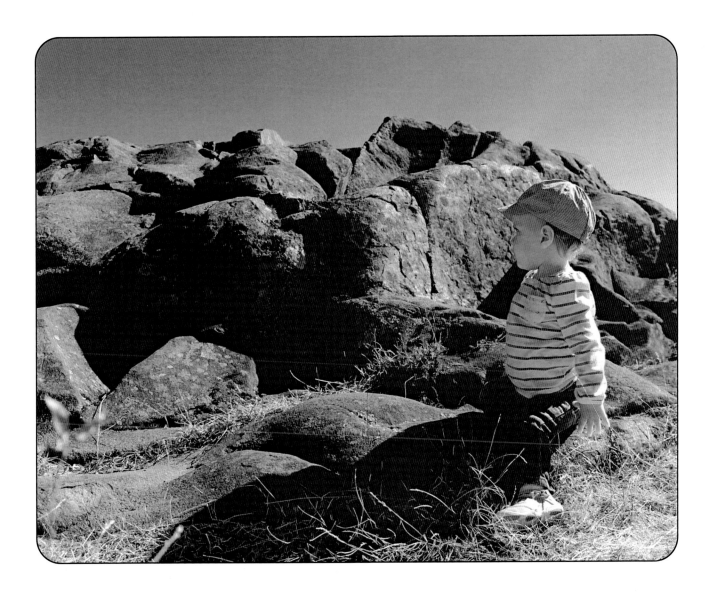

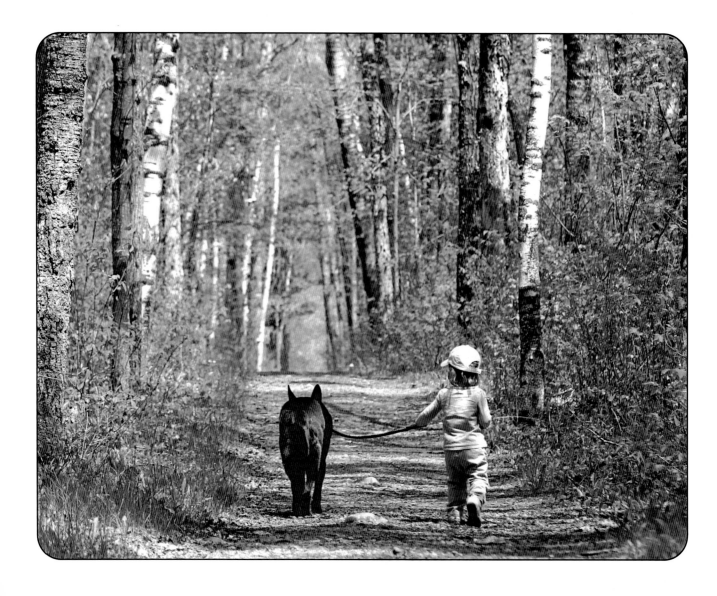

But it is real.

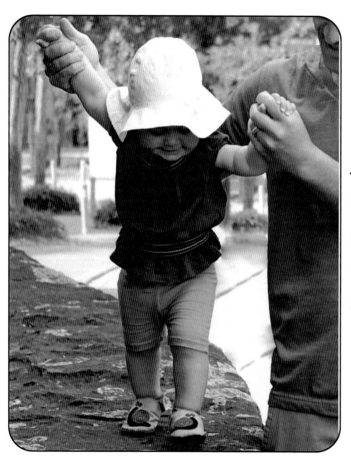

And if you can accept the hardships
with courage and grace,
as a part of the landscape,
then all the joys and beauties
become more real themselves.

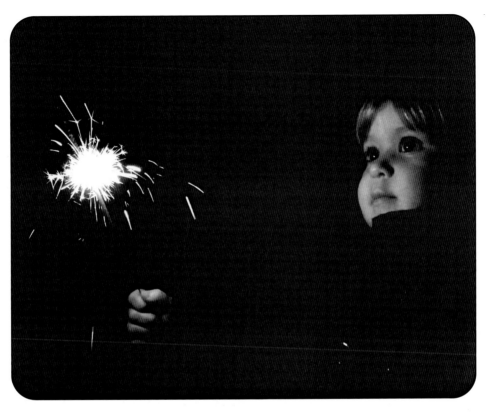

For stars are visible
only in the night sky,
and a candle is a light
only if there is darkness.

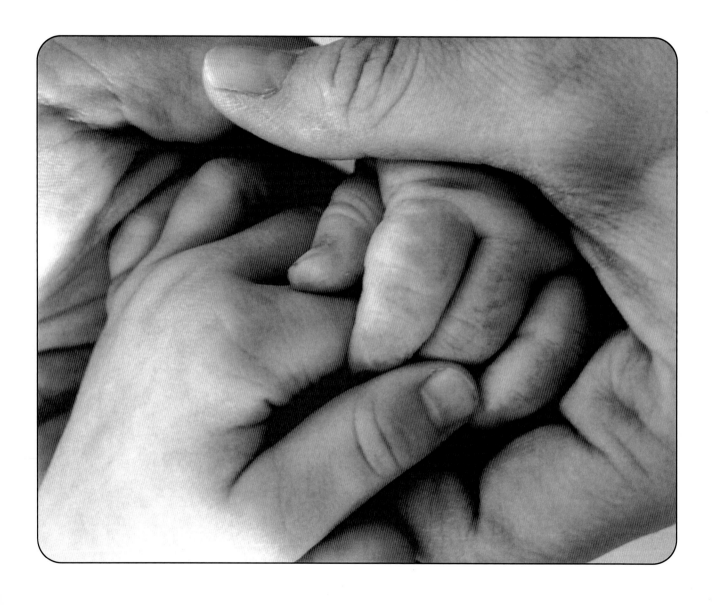

I know you may not understand
all of this, my child.
Or any of it.
But that's all right.
Because the people
Who love you do.

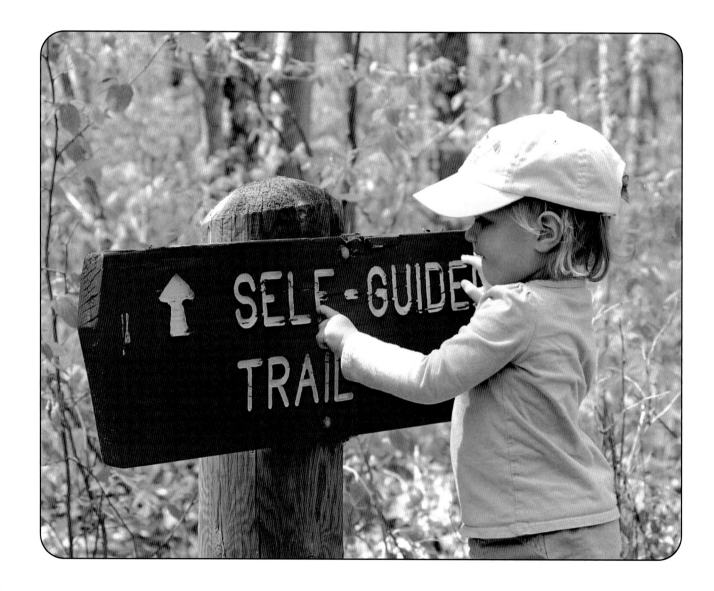

And they'll remind you.
We'll all remind you,
from time to time.
And you'll remind us, too.

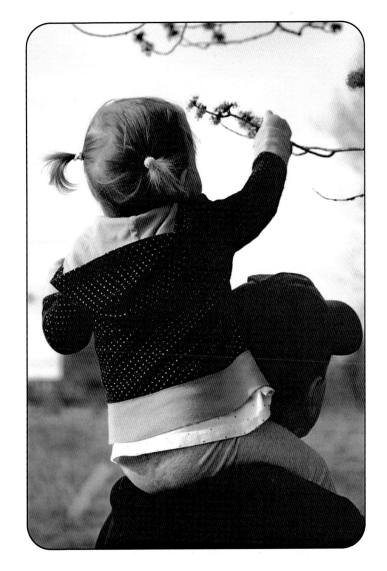

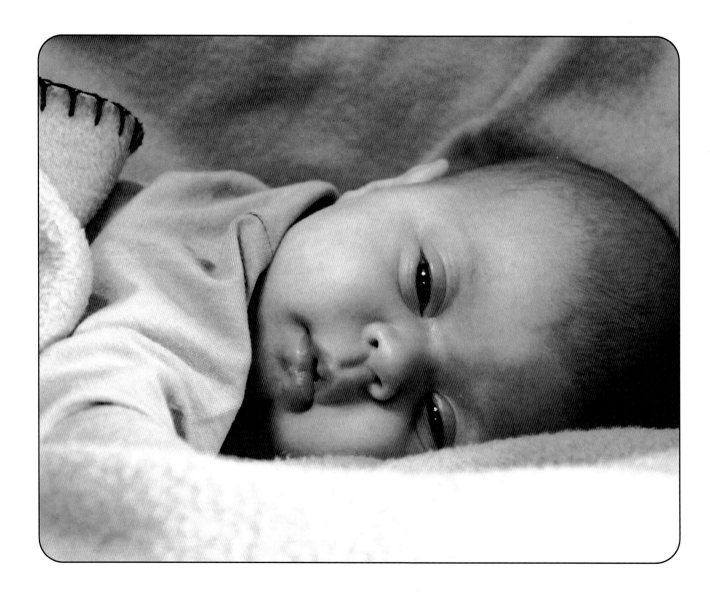

But now, Little One,
go to sleep.
Dream the dreams
you were born to dream.
Become yourself.

Because it won't be very long,
just a moment from now,
and there will be another Little One,
someone precious for you to hold,
to love,
and to welcome
to the world.

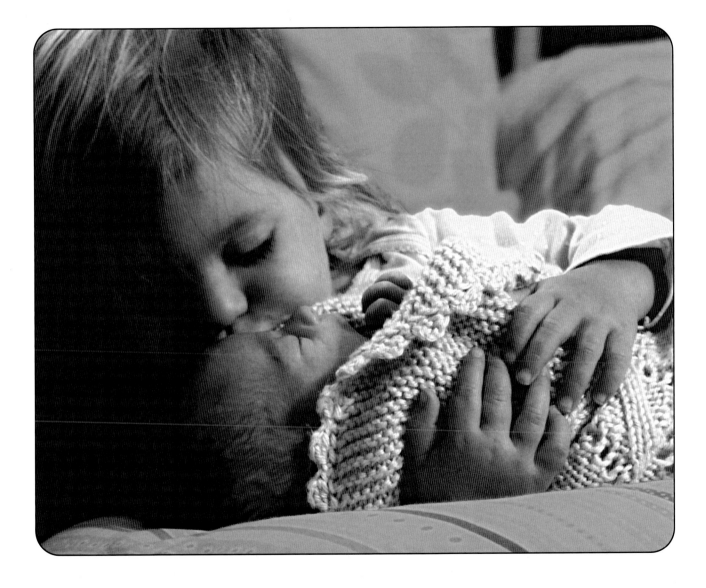

Acknowledgements

Thanks to my daughter-in-law, Katharina, whose sensitive artist's eye captures the moments that make a life; and to Kathy, Bryan, and Eric, who have made mine.

About the Author

Author, musician, artist, and wilderness guide, Douglas Wood is the creator of thirty-three books for children and adults, including the international classic *Old Turtle*. He has presented at countless venues, including the White House and Lincoln Center. Among his many honors and awards are the American Booksellers Book-of-the-Year, Parents Choice Award, and the Christopher Medal. He lives with his family in a log cabin by the Mississippi River.

About the Photographer

Katharina Wood is a science teacher with an advanced degree in forestry. A gifted photographer, she spends much of her time outdoors, where she captures the beauty she sees through the lens. She lives with her family near one of Minnesota's 10,000 lakes. This is her first published collection.